JEN'S GIFT

A Treasure
of Inspirational Insights

JENNIFER ABRAMSON

Edited by Anne Abramson

Full Court Press
Englewood Cliffs, New Jersey

First Edition

Copyright © 2018 by Goal2Soul, LLC

Published in the United States of America
by Full Court Press, 601 Palisade Avenue,
Englewood Cliffs, NJ 07632
fullcourtpressnj.com

ISBN 978-1-946989-16-1
Library of Congress Catalog No. 2018935466

*Editing and book design by Barry Sheinkopf
for Bookshapers (bookshapers.com)*

Cover art by Roxanne Wintjen

The editor gratefully acknowledges the following photo sources:
Page 9, "Colorful Phone Booths," © 2005 London SLR; Page 34,
"Film Strip," © 2006 Bart Everson/Flickr.com; Page 48, "Squirrel,"
© Max Ellis/maxphotographic.com; Page 52, "Purple and Orange
Starfish on the Beach," © 2008 The Marque/Flickr.com, reprinted
under CC by 2.0 license terms; Page 65, still image from the motion
picture *Up* © 2009 Disney-Pixar, used under fair use.

TO JEN

My beautiful, fun-loving daughter,
my best friend, partner in crime,
my inspiration who made me incredibly proud.
You touched so many lives.
May your love and light shine forever.
My love for you is eternal.

ACKNOWLEDGMENTS

A heartfelt thank-you to Lissa Roy, my very special girl friend, whose clever ideas, editing, and energy made this an exciting adventure: She was my backbone. I'm grateful to my cousin Neil, whose feedback, insights, and invaluable advice made a huge difference, who enhanced the quality of the book, inspired me, and helped me through the challenges I faced. I am thankful as well for my assistant and right arm Elena Currie, who helped me every inch of the way. My wonderful, versatile niece Jamie was relentless, working hard to make sure things were done properly and all bases covered; she gave me comfort and peace. Ginger Grancagnolo, my mentor and motivating force, guided and propelled me to turn this dream into a reality. My partner Lou's unconditional love and support gave me strength; my biggest cheerleader, he put his heart into making this a success. My sincere thanks go as well to my attorney, Joe Bahgat, for the generous gift of his time, knowledge, and flexibility. Roxanne Wintjen's inspiring cover is unforgettable,

and I appreciate it enormously. Last, I want to thank Barry Sheinkopf, my publisher, a real professional whose compassion, patience, and commitment created the best result—he went above and beyond, and was such a joy to work with.

—A.A.

MARVELOUS

LIFE'S OBSTACLES ARE OPPORTUNITIES for us to discover our courage, inner strength, and unstoppable power. No matter what the hardship, we cannot always wait for someone to rescue us...sometimes, we must save ourselves. Put on that cape, recognize your potential, uncover confidence, take action, and be the hero of your own story!

SECOND CHANCES

LIFE IS JUST LIKE PAINTING: Shade the lines with hope. Erase the errors with tolerance. Dip the brush with lots of patience. Color it with love"

—Robert Tew

This life is your own work of art. If you don't like what you see on the canvas, you can always paint over it.

SURF'S UP

FEELINGS ARE A LOT LIKE WAVES. We can't stop them, but we can choose which ones to surf."

—Jonatan Martensson

TAKE YOUR BEST SHOT

T ENNIS TAUGHT ME TO TAKE CHANCES; to take life as it comes; to hit every ball that comes to me no matter how hard it looks; to give it my best shot."

—Thisuri Wanniarachichi

GOLF WISDOM

N GOLF AS IN LIFE, it is the follow-through that matters. Take your best swing at life."

—Ty Cobb

Your shot may vary each day. What matters is that you maintain your drive and *stay* in the game. Never let anything put a *wedge* between you and your dreams. If you're having a *subpar* day and fall into a *sand trap*, alter the *grip* or change your *approach*. Don't hesitate to get help from a friend or *caddie* until you get back your *groove*. It's *par for the course* that life will have its ups and downs, one day you will find your *sweet spot*. Be the best you can be, and don't listen to *bogey* negativity that creeps into your mind. Tell your harsh inner critic to kiss your *putt* because you are here to soar like an eagle and fly like a *birdie*. Life is meant to be enjoyed, so have a *ball*, and, if you're feeling silly, wear two pairs of pants in case you get a *hole in one!*

SO WHAT IF MY KNEES ARE KNOCKING?

PEOPLE SAY TO ME ALL THE TIME, "You have no fear." I tell them, "No that's not true. I'm scared all the time. You have to have fear in order to have courage. I'm a courageous person because I'm a scared person. I'm not scared enough to stop trying."

—Ronda Rousey

COLOR YOUR WORLD

L IFE WITHOUT LOVE is like a broken colored pencil: pointless."

—*Black-Adder II*

Having love in your life can come in many forms: a person, pet, hobby, or activity. Who or what do you love? We must start from within. When you learn to love yourself, embrace your quirks, adore your traits, and let go of the need for perfection, everything around you falls into place.

YOU ROCK

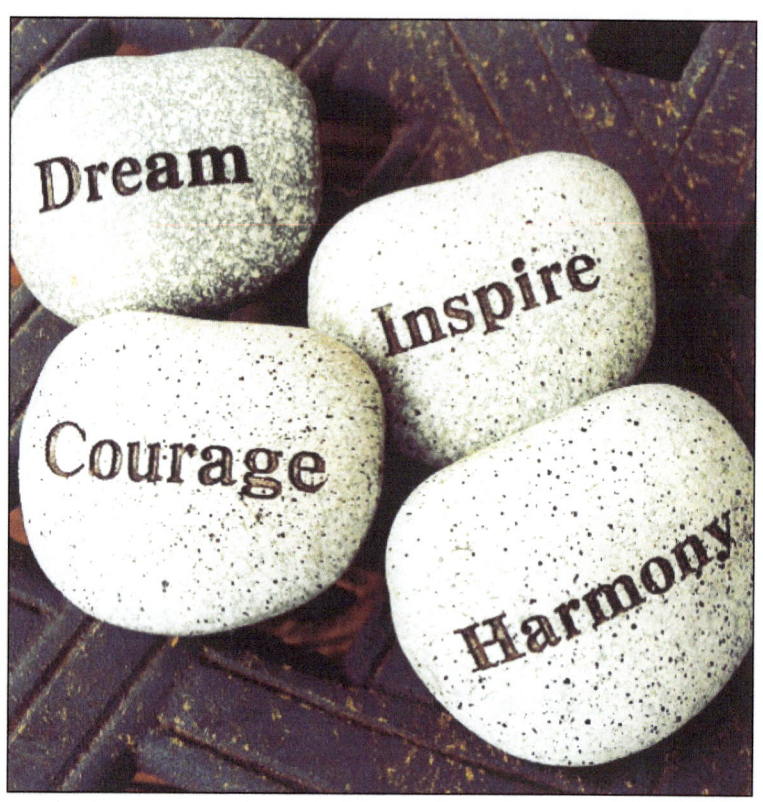

ANY DREAM WE ENVISION CAN COME TRUE if we have the COURAGE to pursue it. Aspire to INSPIRE others and yourself. You will forever live in HARMONY with your authentic self.

DREAM—that which you can see and believe you can achieve.

COURAGE—is not the absence of fear but the triumph over it.

INSPIRE—you have the power to make a meaningful impact in other people's lives.

HARMONY—being true to your heart will help you discover balance and peace.

A GEM FOR YOU

YOUR SMILE IS YOUR LOGO. Your personality is your business card. How you leave others feeling after an experience with you becomes your trademark."

—Jay Danzie

"Your value doesn't decrease based on someone's inability to see your worth."

—Zig Zigler

GRIN AND BEAR IT

BE A HAND that reaches out.
Be a smile for those who have no reason to smile.
Be a light for those who live in darkness.
Show them what it means to truly love.

SWEET DREAMS

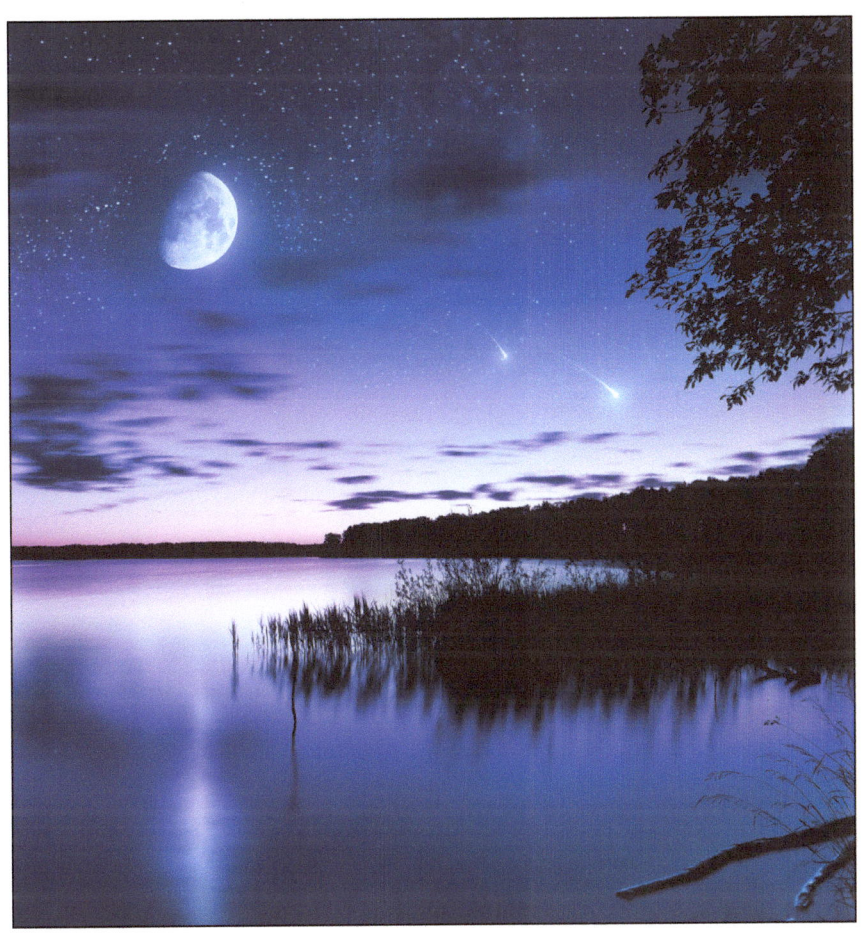

MAY THE LIGHT OF THE MOON guide your spirit and soul.
May the stars grant you wishes and make your heart whole.
Let every night sky bring you peace and contentment
And help you let go of all nagging resentment.
Good night, bright full moon with your flickering gleams,
It's time to escape to a night full of dreams.

A HEAVENLY SMILE

LOOK UP AT THE BRIGHT SKY and smile. Today, give a stranger one of your smiles. It might be the only sunshine he or she sees all day.

"A smile is happiness you will find right under your nose."
—Tom Wilson

WHERE ARE MY KEYS?

METAPHORICALLY SPEAKING, when navigating the road of your life, you can either take the wheel, take a back seat, or get taken for a ride. Which part of the car will you choose?

Furthermore, if someone is ever driving you crazy, stop giving them the keys and get your awesome self back in the driver's seat!

A MOVABLE TARGET

YOU MISS A HUNDRED PERCENT of the shots you don't take. Shoot an arrow in the air. Where it lands, paint a bulls eye!"

—Elizabeth Streb

A MARBLE JUST FOR YOU

A FRIEND OF MINE once said to me,
"This marble is for you,"
'Cause I was sure that I'd lost mine
When life became so blue."
But now I know, despite the odds,
And that my marbles may be few,
This friend of mine reminded me
Life can be joyous, too.
So here's a marble just for you
And only for some fun,
So when you think you've lost your marbles
You know you still have one.

NEEDLES IN HAYSTACKS

WHEN YOU'RE GOING THROUGH a difficult time in life, try not to let yourself feel too discouraged or defeated. Remember, it's often the last key in the bunch that opens the lock. Have faith and trust in the universe that the answer to your troubles exists, because it only takes one—that right key—to unlock a world full of wonderful possibilities.

BETTER THAN GOLD

WHOM OR WHAT DO YOU TREASURE? Personally, I treasure people, those wonderful genuine beings who radiate goodness from their hearts, the special ones who uplift you, accept you, encourage you, and amaze you. With their warmth, kindness, humor, and compassion, they can forever be trusted and always make you feel important. Hold onto those precious gems, for they are the pure gold that will make your life rich.

THERE'S ALWAYS GLUE

AT TIMES WHEN YOU FEEL SHATTERED or defeated, remind yourself that you are not alone. All of us get broken in some way; what matters is how we rise up and put the pieces back together.

"Sometimes good things fall apart so better things will fall together"—Marilyn Monroe

"Life always offers you a second chance: It's called tomorrow" —*Amy Rees Anderson*

STICKING YOUR NECK OUT

WHY FIT IN WHEN YOU WERE **born to stand out?** Be a Fruit Loop in a world of Cheerios. Embrace your individuality, and never be afraid of being different. Be afraid of being the same as everyone else. All you have to be is yourself.

CUT A PIECE OF TRIVIA

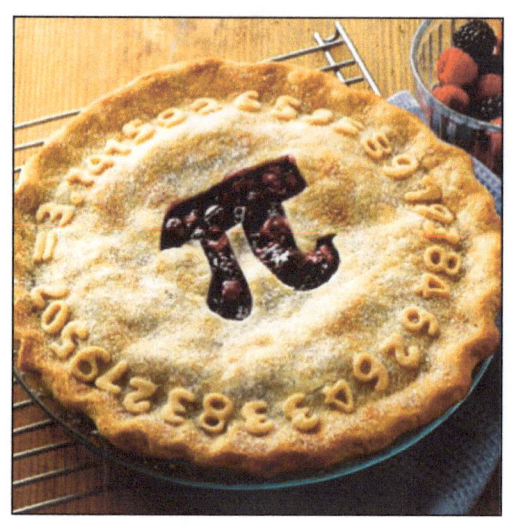

I PREFER PI: 3.14 LOOKS LIKE PIE (now I'm hungry!). 111, 111, 111 x 111,111,111 = 12,345,678,987,654,321 (didn't learn that one in Math class). A shrimp's heart is in its head (then how does the shrimp in love distinguish between his head and his heart?). Almost is the longest word in the English language with all the letters in alphabetical order (trusting that is correct or else I'll be searching in the dictionary all day long). All porcupines float in water (cute mental images of porcupines in life jackets). Hot water is heavier than cold (no wonder saying you're in cold water now won't carry the same weight). When hippos are upset, their sweat turns red (what about when they are hungry, hungry hippos?). The average four-year-old child asks over 400 questions a day (holy moly. . .tipping my hat to all of you extremely patient mamas out there!). A baby spider is called a spiderling (kind of makes me less creeped out by spiders. . .kinda).

F.E.A.R.

DO ONE THING EVERY DAY that scares you."

—Eleanor Roosevelt

Confront your fears, and they won't be your fears anymore..
Do you know when National Snake Day is?

SHARING HEARTS

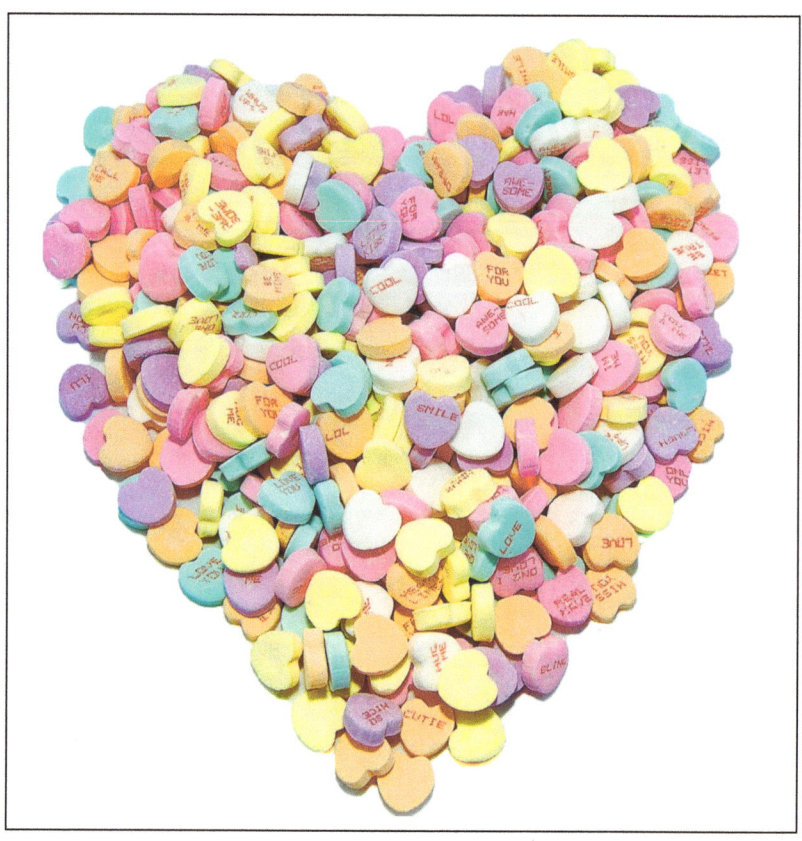

A SIMPLE GOOD DEED can have a powerful impact on another person's life. Random acts of kindness are my favorite! Smiles are free, and compassion doesn't cost anything. Lend a helping hand or a shoulder to lean on. Encourage a friend, or compliment a total stranger. What may seem small to you could make a huge difference in completely changing someone else's day for the better. If everyone in the world lifted each other up, it would be transformed into one giant heart-shaped sphere of positive energy.

ABC'S COME ALIVE

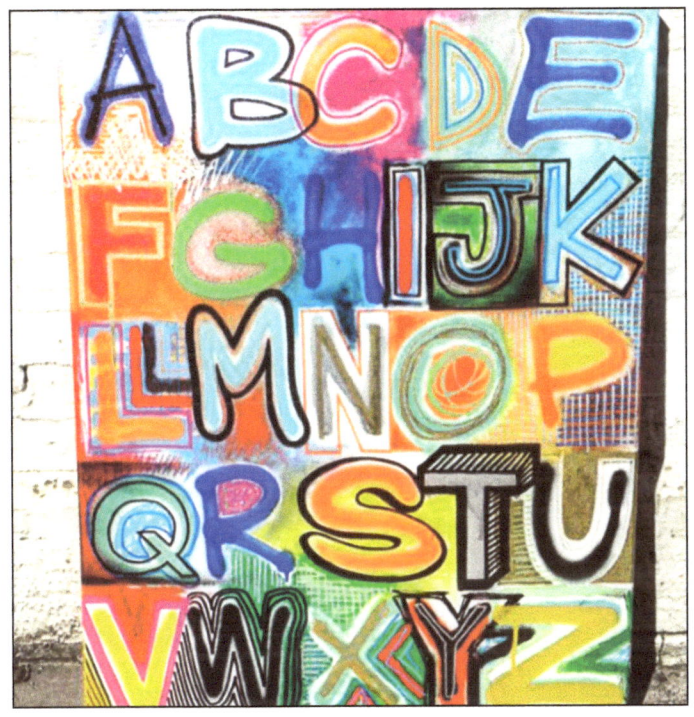

I F PLAN A DOESN'T WORK OUT, that's OK! The alphabet has 25 more letters. Be flexible. Learn to adapt. Keep calm and carry on. Life is what you make it. Inspirational Alphabet: A=Amaze yourself. B=Be kind. C=Create. D=Dream big. E= Enjoy life. F=Fear not. G=Give thanks. H=Have fun. I=Imagine. J=Jump for joy. K=Know your worth. L=Love fully. M=Meander. N=Never quit. O=Open your heart. P=Pray. Q=Quiet the mind. R=Relax. S=Sing along. T=Trust the Universe. U=Unite. V=Venture out. W=Wonder. X="X"tend a helping hand. Y=Yearn for inner peace. Z=Zig-zag through challenges.

TAKE THE FIRST STEP

F YOU DON'T GO AFTER what you want, you'll never have it. If you don't ask, the answer will always be no. If you don't step forward, you will always be in the same spot."

—Nora Roberts

"Go for what you want, ask questions, and take that one step forward, because you never know where it might lead."

—Anon.

GETTING THERE

FAITH BECOMES A BRIDGE between where you are and where you want to go."

—T.D. Jakes

"Until you cross the bridge of your insecurities, you can't begin to explore possibilities."

—Tim Fargo

BE UNIQUE

KNOW I AM A FLOWER TOO, but still. . . .
What is it like to be a dandelion in a vase full of roses?

SORRY, WRONG NUMBER

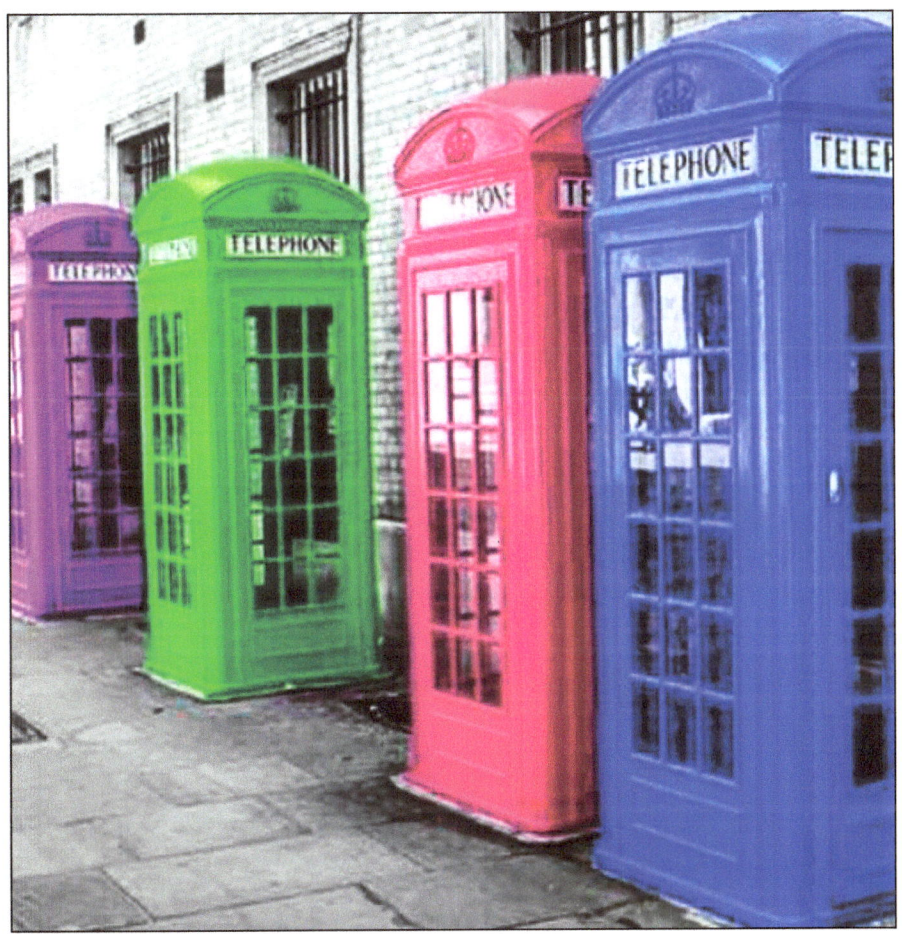

KEEP THE TELEPHONE OF YOUR MIND open to peace, harmony, wellness, love, and abundance. Then, whenever doubt, trepidation, or anxiety try to call you, they will keep getting a busy signal. . .and soon they will forget your number.

WHO'S IN CONTROL?

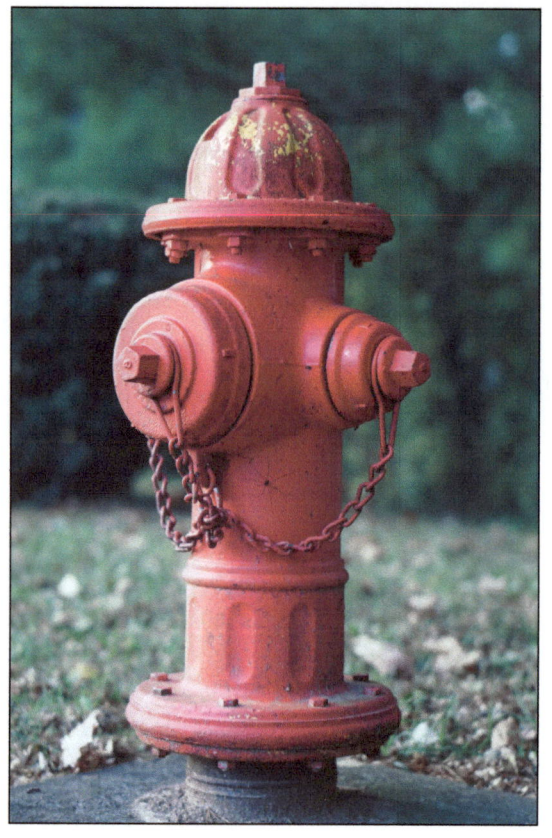

SOMETIMES YOU'RE THE DOG, and sometimes you're the fire hydrant. This figure of speech reflects the ups and downs of life. Some days you're on top of the world (the dog in control), while at other moments you feel like rock bottom (the fire hydrant getting peed upon). Throughout these life changes, keep in mind that what goes up must come down, and vice versa. Be nice to everyone on your way up, because you pass them on the way down. You never know when you'll need someone to lean on.

MY BFF

THERE ARE SOME PEOPLE in life who make you laugh a
little louder smile a little bigger, and live just a whole
lot better! Celebrate Friendship Day by calling a true
friend who gives you total freedom to be yourself.

LOVE SQUARED

ONE OF THESE DAYS, a special person is going to walk into your life and make you realize why it never worked out with anyone else.

Right now someone you haven't met is out there wondering what it would be like to meet someone like you.

CRAYOLA INTELLIGENCE

WE COULD LEARN A LOT FROM CRAYONS. Some are sharp, some are pretty, and some are dull. Others are bright, and some have weird names, but they've all learned to live together in the same box."

—Robert Fulghum

WHERE'S THE PEANUT BUTTER?

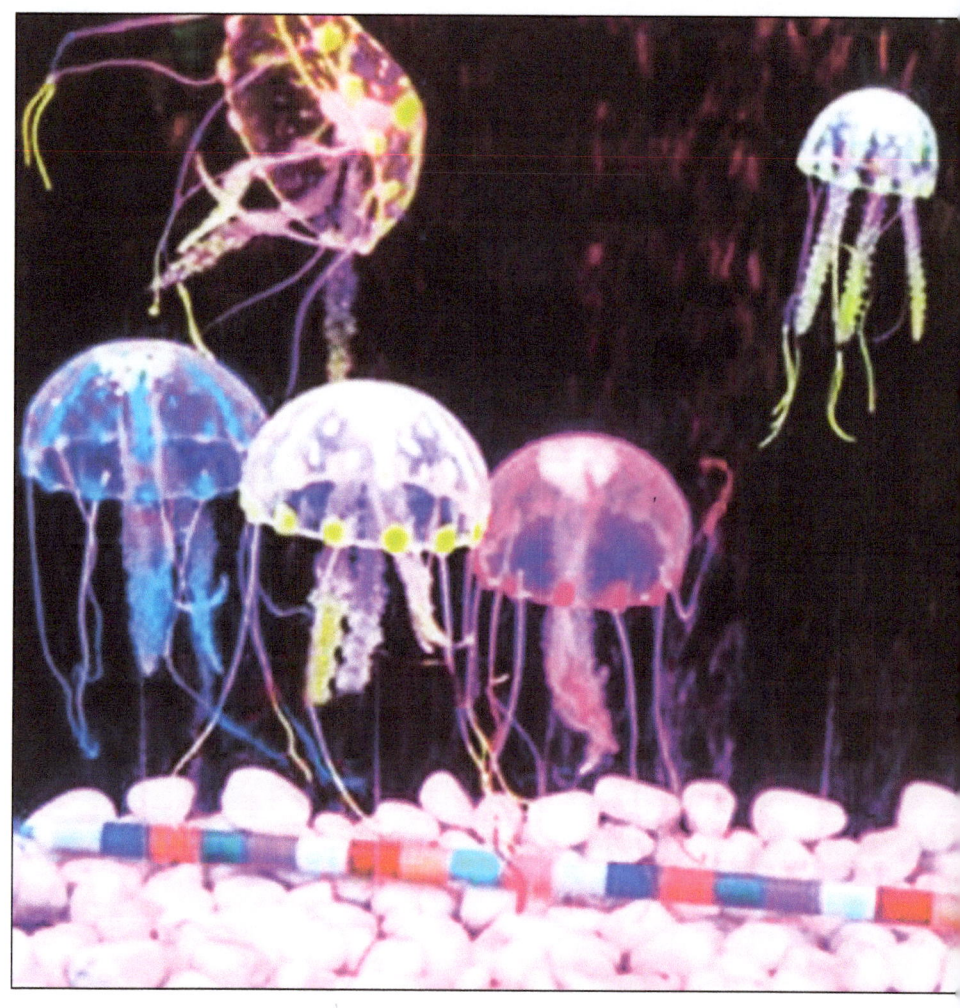

ID YOU KNOW THAT JELLYFISH are not actually fish? The moral of this fun fact is to never let labels define you. Just because someone calls you a word does not mean that is who you are. Create your own identity and define yourself.

SEA THE SHADOW

DON'T LET THE SHADOWS OF YESTERDAY spoil the sunshine of tomorrow."

—Nandina Morris

Life is better with a little sand between your toes.

HONEY BEE HAPPY

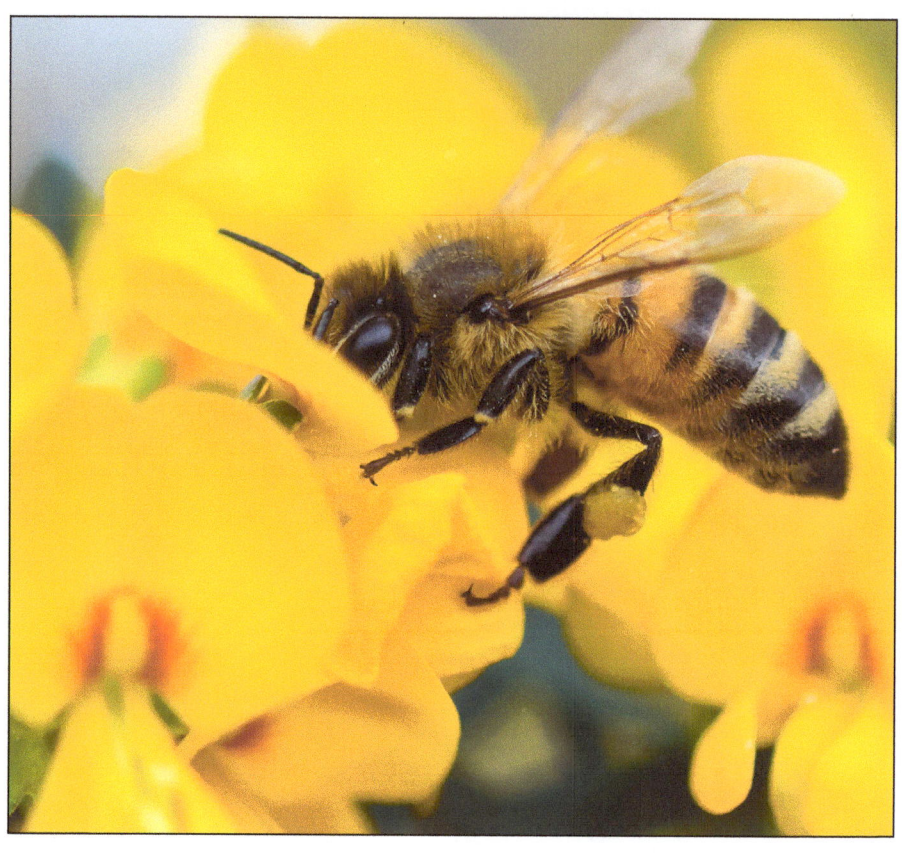

T HE FLOWER DOESN'T DREAM OF THE BEE. It blossoms, and the bee comes."

—Mark Nepo

LET'S PLAY LEAPFROG

THE LITTLE FROG SAT on his lily pad, thinking of all he wished he had. If only he could get to shore, life would offer so much more, but he was afraid to take the leap. If he missed, the water was deep, so he sat safe amongst the muck, grumbling that he was stuck. He knew he would get nowhere if he continued to sit right there. Finally he cast his doubts aside and made the leap of faith in stride.

"Please remember this moral is true. Your future depends mainly on you. Don't just sit there and stress. Take a leap of faith for success!"

—Shirley Thomas

SEASONS

WHEN LIFE GIVES YOU SOMETHING that makes you feel afraid, that's when life gives you a chance to be brave. Strength doesn't come from what you can do. . .it comes from overcoming the things you once thought you couldn't."

—Rikki Rogers

No matter how rough your circumstances are or how cold the world might feel, always find warmth in your heart to light the fire within and keep pushing forward. Have hope. Change is inevitable. Hardships won't last. Seasons change. So will you.

UNBREAKABLE WINGS

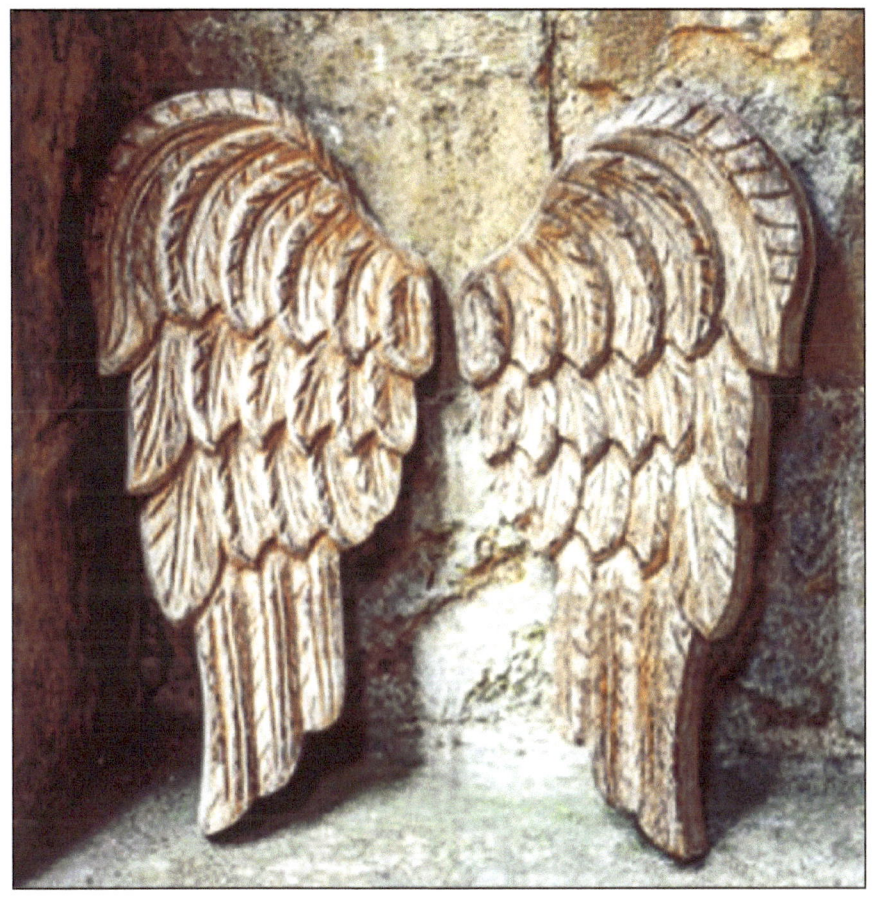

THE BEST KINDS OF PEOPLE are the ones who come into your life and make you see the sun when you once saw clouds. They are the ones who are like angels that lift us to our feet when our wings have trouble remembering how to fly. They are the people who believe in you so much, you start to believe in you too. . . those who love you simply for being you—the once in-a-lifetime kind of people!"

—Ranita Isaac

YOU NAILED IT

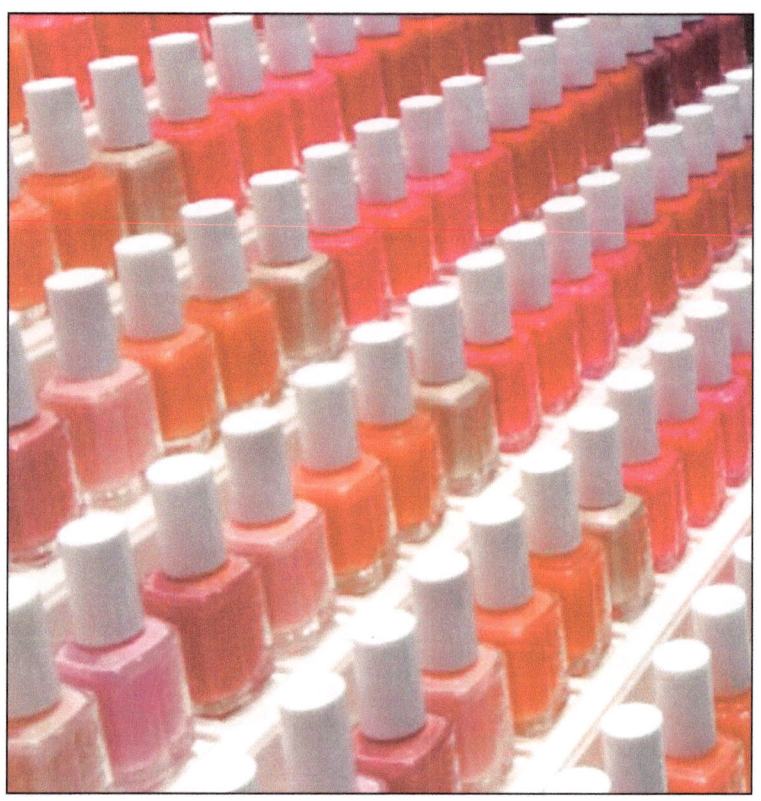

LIKE AN ASSORTMENT OF NAIL POLISH, we come in different colors, hues, shades, shapes, and sizes. This is what makes life beautiful! If we were all the same, the universe would be dull, bland and booooring! Embrace your uniqueness and always be accepting of other people's race, ethnicity, body shape, gender, culture, or religion.

The heart, soul, and spirit of people are far more important that their exteriors. Get interested in and know those who differ from you. A new nail polish can brighten up your fingers, but a new friend just might color up your world.

REACH FOR THE SKY

GO FOR YOUR GOALS even if they seem unreachable. Work toward your dreams, and they will become a reality.

"If you've built your castles in the air, your work need not be lost. That is where they should be. Now put foundations underneath them."

—Henry David Thoreau

DON'T BOX YOURSELF IN

SOMETIMES WE HAVE TO FALL APART to rebuild ourselves as the way we wish we had been all along. In a place of rock-bottom crisis lies opportunity: breakdowns lead to breakthroughs.

GOOD MORNING, SUNSHINE

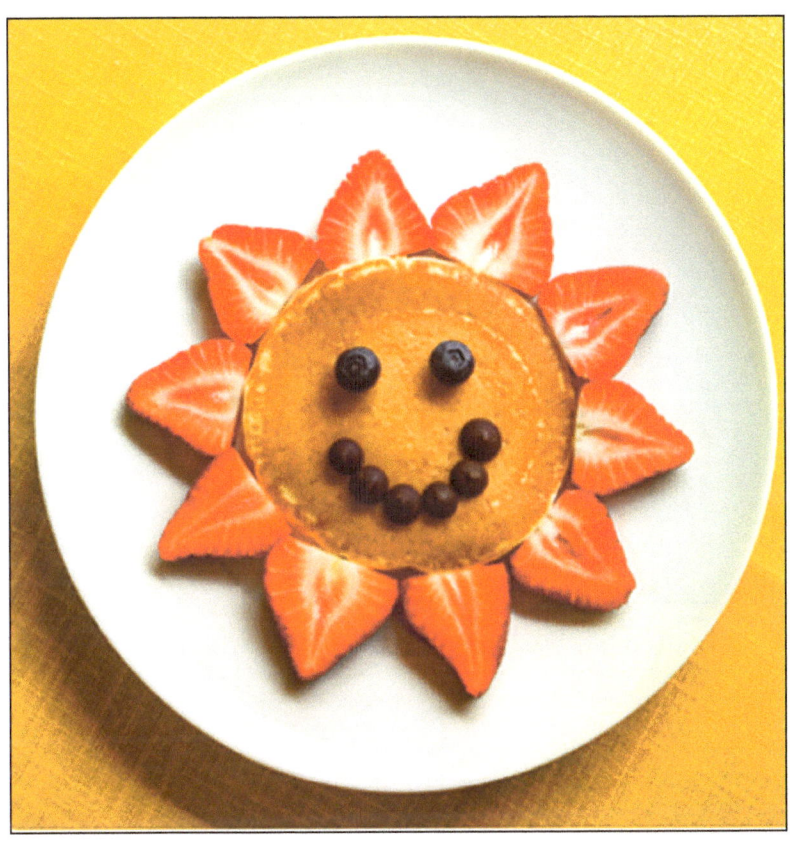

W E SHOULD START EACH DAY OFF with a smile and breakfast. But how about starting your day with a smile *in* your breakfast?

SMILE. . .CLICK!

LIFE IS LIKE A CAMERA. Focus on what's important. Capture the good times. Develop from the negatives. If things don't work out. . .take another shot!"

—Ziad K. Abdelnour

WHAT DOES "ARF" MEAN?

DOGS TEACH US a lot of things, but none more important than to love unconditionally.

"An animal's eyes have the power to speak a great language."
—Martin Buber

Charlie looks very Zen, plus deep in thought, in the picture above, don't you think? I wonder what was going through his mind.

GO BEYOND

I T CAN BE NERVE-WRACKING AND SCARY to step outside your comfort zone, but don't allow yourself to be fenced in by your fears; otherwise, you will miss out on a whole world of exciting possibilities and fulfilling experiences!

"F.E.A.R = False Evidence Appearing Real."

—Neale Donald Walsch

Push through those apprehensions and doubts so that you can make something happen instead of making nothing happen. It will be worth the risk.

SPECIAL FRIENDS

ALL WE NEED IS A WARM embrace to make our stress melt away.

"Share our similarities; celebrate our differences."

—M. Scott Peck

FEAR OF FLYING

WHEN EVERYTHING SEEMS to be going against you, remember that an airplane takes off against the wind, not with it."—Henry Ford

You are the pilot in command on your flight to success. The true test of our strength and perseverance is measured when we are faced with adversity. If things were easily handed to you, you'd never have an opportunity for personal growth. Don't allow obstacles to stop you from trying or flying. Even when it feels like you are taking steps back, don't quit.

Believe in the magic of your dreams, and always hold onto hope. Never give up, because you will soar. The ride might be bumpy at times, but when you land safely at your destination of peace and happiness, it will have been worth it.

UNWRAP EACH DAY

UNWRAP EACH DAY as a fresh start to dazzle the world with your radiant smile, compassionate heart, and delightful spirit. The greatest gift you can receive is another day of your life, so make the most out of this privilege and live each moment as a thank-you note!

"Yesterday is history. Tomorrow is a mystery. Today is a gift. That's why it's called the present."

—Eleanor Roosevelt

LIGHTEN UP

HAVE NOT FAILED. I've just found 10,000 ways that won't work. Our greatest weakness lies in giving up. The most certain way to succeed is always to try just one more time."

—Thomas Edison

Let's absorb these powerful words from an esteemed inventor to ignite the spark inside us and never surrender to the darkness. After all, it only takes one idea. One spark. One thought. One discovery. One prayer. One moment to change the dynamic of your entire life. Keep holding on to the one thing that will set everything in motion and make anything possible. Just believe!

LIFE IS. . . .

LIFE IS AN OPPORTUNITY; benefit from it.

Life is beauty; admire it.

Life is a dream; realize it.

Life is a challenge; meet it.

Life is an assignment; complete it.

Life is a struggle; accept it.

Life is a tragedy; confront it.

Life is an adventure; explore it.

Life is luck; make it.

Life is life; fight for it.

—Mother Theresa

SPLISH-SPLASH

WASH OUT ALL your worries,

Soak away your sorrows,

Clean the pain from your past,

Water down any stressors,

Refresh the body,

Clear your mind,

Invigorate your soul,

Awaken the spirit of your inner child.

Love yourself as if you are

the most precious thing in the world,

because you are!

UNMASK!

WE CREATE A MASK to meet the mask of others. Then we wonder why we feel so alone."

—Brenda Shoshana

Sometimes we hide behind a facade to protect ourselves. Don't wear a mask for so long that you forget who you are beneath it. Being authentic comes from self-acceptance and allowing people to see the real you. Sure it can be scary and takes vulnerability. It allows you to connect with others on a much deeper, genuine level. If we could all remove our masks and not judge ourselves or each other, the world would be a better place.

TAKE A LEAP OF FAITH

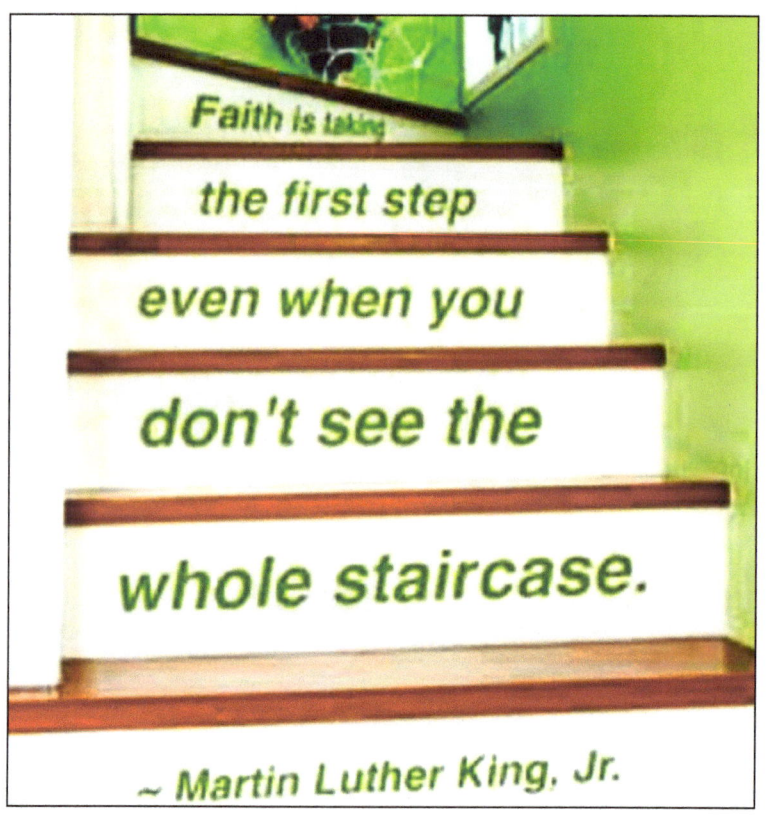

Faith is taking the first step even when you don't see the whole staircase.

~ Martin Luther King, Jr.

AITH IS TAKING THE FIRST STEP even when you don't see the whole staircase."

—Martin Luther King, Jr.

THIS BUD'S FOR YOU

THE FLOWER THAT BLOOMS IN ADVERSITY is the most rare and beautiful of all."

—The Emperor, Disney's *Mulan*

Some of the most amazing, inspiring things stem from the most difficult and darkest of times. Remember, even flowers have to grow through dirt.

HEAVY LIFTING

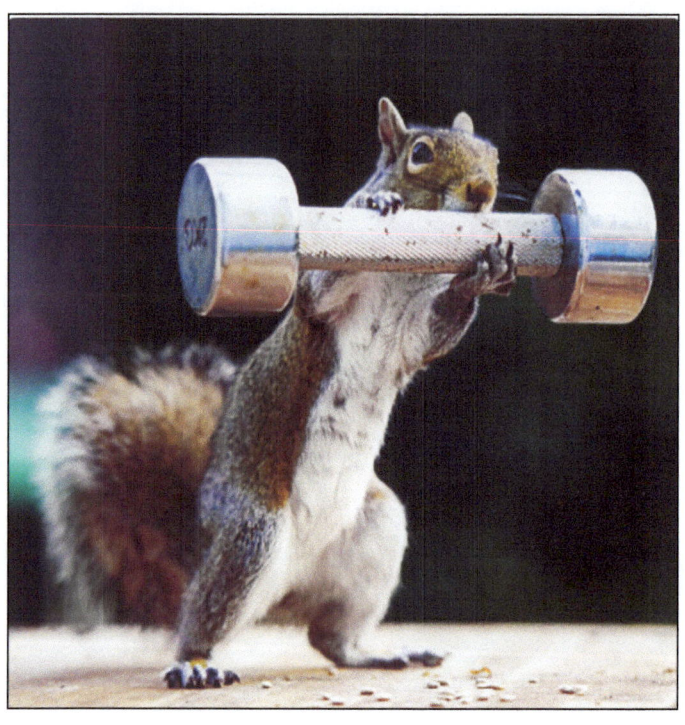

Y OU WERE GIVEN THIS LIFE because you are strong enough to live it."—Ain Eineziz

When things seem like an uphill battle, remember to believe in yourself and all that you are. No matter how defeated and broken you feel, always trust in the depths of your heart that you *are* capable of overcoming obstacles. One day you will look back on those difficult challenges and hard times, wondering how you made it through. Only then will you realize the magnitude of the power that you had inside all along.

BURN, BABY, BURN

THE SMALLEST SPARK ignites a fire that lies deep inside you, and suddenly everything is possible."

—Jenn Herndon

KNOCK KNOCK

I F YOU CAN'T FIND THAT DOOR, try a window. Then try a new door. Try a new window. Life offers many doors and windows. Keep your eyes open for them. Consider the fact that the reason the door is closed is that the universe knows you are worth so much more.

"When one door of happiness closes, another one opens."
—Helen Keller

MUNDANE CAN BE NICE

APPRECIATE THE LITTLE THINGS in life, because one day you will look back and realize they were the big things. We allow foolish things to tear our lives apart. Far too many times, we let the unimportant into our mind. Then it's usually too late to see what made us blind. Be sure to let people know how much they mean to you.

"Too often we don't realize what we have until it's gone. Sometimes we wait too late to say, 'I'm sorry, I was wrong.' Sometimes it seems we hurt the ones we hold dearest to our heart."

—Marilyn Monroe

MONKEY LOVE

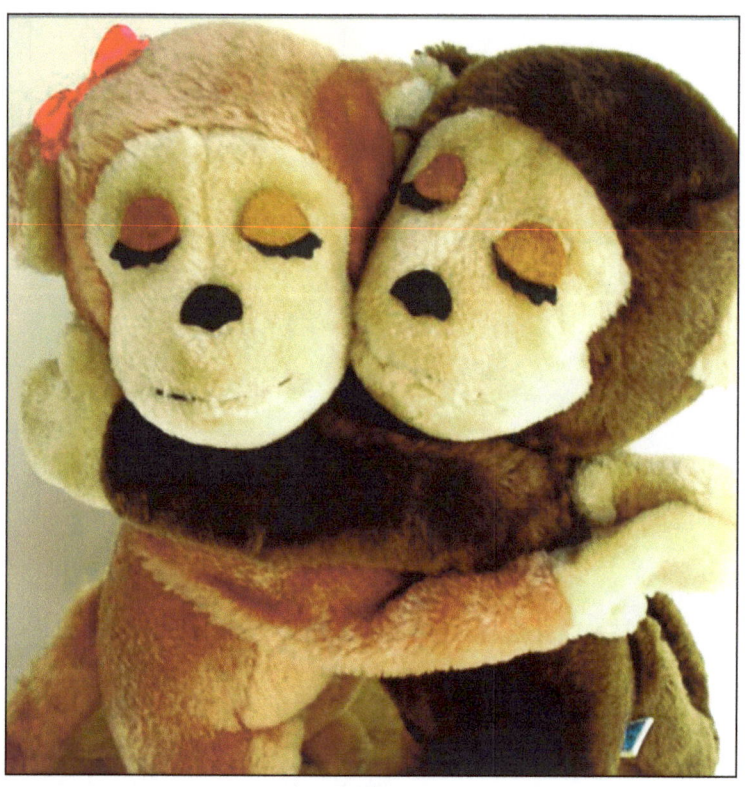

THEY SAY YOU SHOULD PUT OUT to the world what you wish to receive. Aside from monkeys being my favorite animal (holding a chimpanzee is on my bucket list), this picture reflects the essence of the kind of love I dream of finding.

True love is pretty simple and magical, yet not so easy to find. At the end of the day, most of us just want to find our soul's counterpart, the one who makes us laugh and smile, with whom we can be our complete goof ball self and also share meaningful conversations, a teammate with whom we can tackle life together and support one another.

TWINKLE, TWINKLE, LITTLE STARFISH

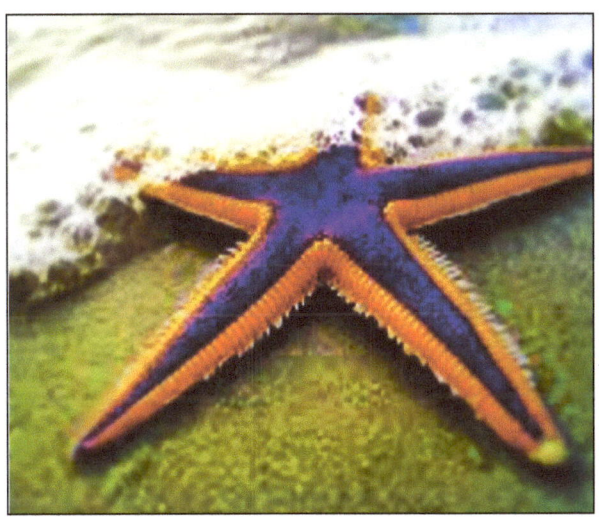

AN OLD MAN WAS WALKING on a beach one morning after a storm. In the distance, he could see someone moving like a dancer. As he came closer, he saw that it was a young woman picking up starfish and throwing them into the ocean. "Young lady," he asked, "why are you throwing starfish into the ocean?"

She replied, "The sun is up, the tide is going out, and if I don't throw them in, they'll die."

"But do you realize that there are many miles of beach and thousands of starfish? You can't possibly make a difference."

She listened politely, bent down, and threw another starfish beyond the grasp of the surf. "It made a difference to that one," she said.

—from a story by Loren Eiseley

SHINE ON

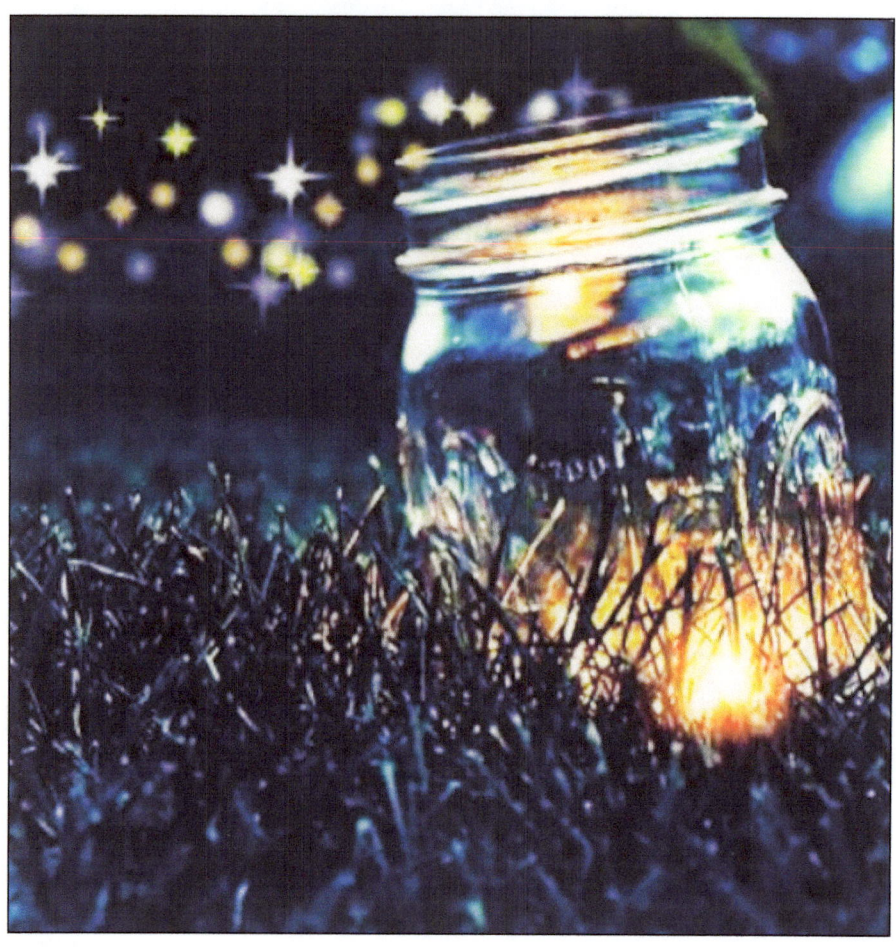

SHINE YOUR LIGHT AND ILLUMINATE your life, your heart, and your dreams. Recapture a childlike sense of wonder and adventure—and always remember to stop and chase the fireflies!"

—Heidi Thompson, *Scentsy*

NO "NEIGH"GATIVITY

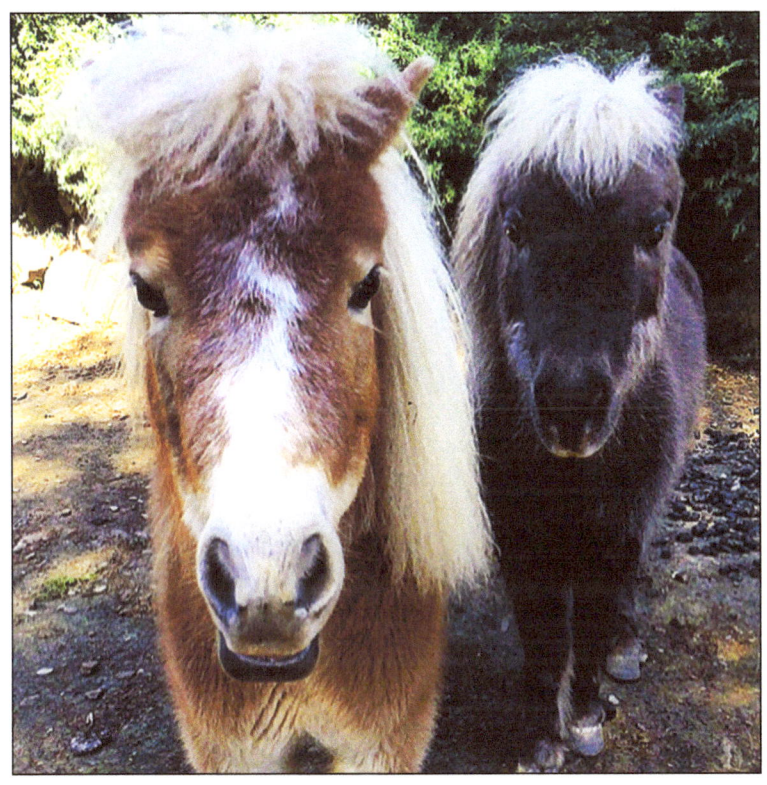

T HROWBACK TO WHEN I got to horse around with these cuties. "Friendship isn't about whom you have known the longest."

—Mikaela Tiu

It's about who came and never left your side. Side by side or miles apart, friends are forever close to your heart.

AN EXPLOSIVE MESSAGE

BE CONFIDENT IN WHO YOU ARE. Don't allow others to influence the way you feel about yourself. Refuse to let others hurt you. Besides, what anyone thinks of us is none of our business. Focus on your well-being, find your purpose, and do what makes you happy. Oh—and never forget to remind yourself that *You Are Da Bomb Dotcom.*

WOULD I STEER
YOU WRONG?

BE OUTSTANDING IN YOUR FIELD. Eat plenty of greens.
Maintain your graze. Swing your tail and hoof it.
Know that it's okay to feel a bit moo-dy at times.
Do what scares you. Don't be a cow-ard.
If someone makes a hurtful remark, allow it to go
in one ear and out the udder.
Don't be afraid to stand apart
from the rest of the herd.
Never lose your sense of humooor.
Live to the fullest by milking life for all it's worth!

AHA!

CAN YOU REMEMBER THE LAST TIME you had a light-bulb moment, sudden enlightenment, an awakening or realization that inspired you? One of mine was when I discovered that inner peace truly comes from staying in the present moment and not ruminating over the past or obsessing over the future. Living in the now, remembering to breathe, and treating myself with the same kindness I would treat a friend are a key component of self-care and empowerment.

"Find what sparks a light in you so that in your own way you can illuminate the world."

—Oprah Winfrey

SOAR THROUGH FEAR

F YOU WANT TO FLY, give up everything that weighs you down."—Toni Morrison

Become like a bird. Expand your wings, break through your fears, and soar above your troubles. Even if your wings are broken right now, keep in mind that sometimes we have to endure hurt in order to grow.

"We must fall in order to grow and lose in order to gain, because life's greatest lessons are often learned through pain."

—Naruto Uzumaki

SEALED WITH A KISS

FOR ATTRACTIVE LIPS, SPEAK WORDS OF KINDNESS. For lovely eyes, seek out the good in people. For poise, walk with the knowledge that you never walk alone. Keep peace in your soul, love in your heart, wisdom on your shoulder, and grace on your lips.

GRANDPA'S GIRL

 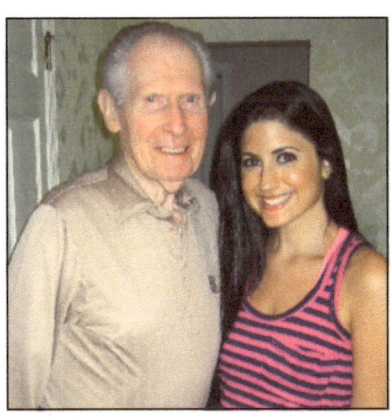

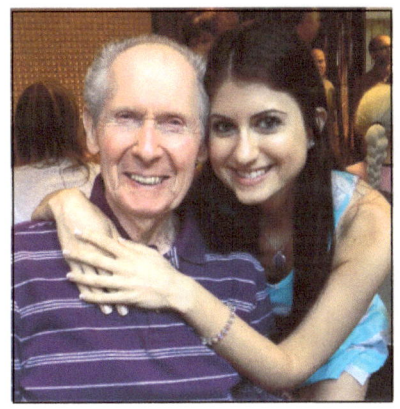 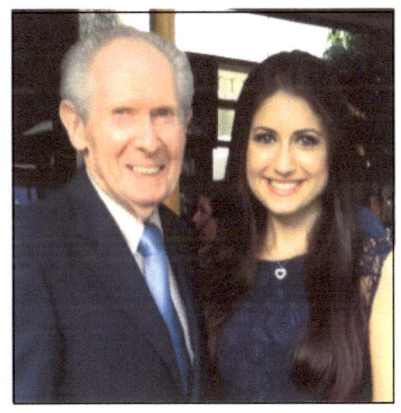

SILVER IS HIS HAIR and gold is his heart. My grandpa is one of my favorite people on the planet, a spry 90-plus years of age. To have an amazing grandpa who is incredibly sweet, wise, funny, caring and precious—I feel immensely lucky. If you are blessed to have grandparents in your life, treasure the quality time you get to spend with them. Their wisdom, insight, learned lessons, values, and incredible stories enrich our lives so very much.

(Grandpa passed away in November 2017.)

JUST JEN

GO FORWARD IN LIFE with a twinkle in your eye and a smile on your face, and with great and strong purpose in your heart."—Gordon B. Hinckley

"Above all, watch with glittering eyes the whole world around you, because the greatest secrets are always hidden in the most unlikely places. Those who don't believe in magic will never find it."—Roald Dahl

www.ingramcontent.com/pod-product-compliance
Lightning Source LLC
Chambersburg PA
CBHW052059170526
45162CB00012BA/84/J